All you need to know about
Rubber Stamping

Maggie Wright

Search Press

First published in Great Britain 1995

Search Press Limited
Wellwood, North Farm Road,
Tunbridge Wells, Kent TN2 3DR

Reprinted 1996, 1997, 1998, 2000, 2001

ISBN 0 85532 794 4

If you have difficulty in obtaining any of the
materials or equipment mentioned in this book,
please write for further information to the Publishers:
Search Press Limited, Wellwood, North Farm Road,
Tunbridge Wells, Kent TN2 3DR, England.

*In memory of Jenny, who was an inspiration to
those whose lives she touched.*

The author wishes to thank the many friends and companies
in the stamping industry who gave her their support and
encouragement. Thanks to Sandra and Sam for their
unending patience; to Val, who is the only person able to read
her writing; and special thanks to her husband, Derek, who
never once complained about the house being turned into a
stamp studio!

Acknowledgements to the following companies:

Delafield Stamp Co. Ltd.
514 Wells Street, Delafield, Wisconsin 53018, U.S.A.

Stampendous Inc.
1357 South Lewis Street, Anaheim, CA 92805, U.S.A.

Hero Arts Rubber Stamps
The Old Wine Cellar, 9 Castlemead Gardens, Warehams Lane,
Hertford, Herts. SG14 1JZ

Personal Stamp Exchange
345 So. McDowell Blvd., Ste. 324, Petaluma, CA 94954, U.S.A.

Rubber Stampede Inc.
Berkley, California, U.S.A.

The Walt Disney Company.

Warner Bros.

Posh Impressions
30100 Town Center Dr., Ste. V, Laguna Niguel, CA 92677, U.S.A.

Embossing Arts Company
PO Box 626 (1200 Long Street) Sweet Home, Oregon 97386, U.S.A.

Uchida of America Corp.
1027 East Burgrove Street, Carson, California 90746, U.S.A.

Clearsnap (Colour Box)

Printed by Elkar, S. Coop. 48180 Loiu, Spain

Contents

Introduction

Rubber stamping is a fascinating craft form that is becoming more and more popular. It really is a lot of fun – once you start, you may not want to stop

In this book, I am going to show you how easily and quickly you can give a professional look to your own unique hand-made greetings cards, wrapping paper, matching gift tags, writing paper, invitations, bookmarks and many other stationery items. I will explain the various ways you can colour, emboss, mount and decorate your stamped images, depending on the effect you want to achieve.

The craft of hand-made greetings cards dates back to the Victorian era. These days, this personal art form has almost been ousted by mass-production of commercial greeting cards – but just think how special someone will feel to receive a hand-stamped card from you.

You will soon be experienced in making your own beautiful cards and other stationery items. Enjoy experimenting with your stamps and colours and the wide range of fascinating accessories available; try out some of the endless combinations, leaving your own unique stamp on your work of art!

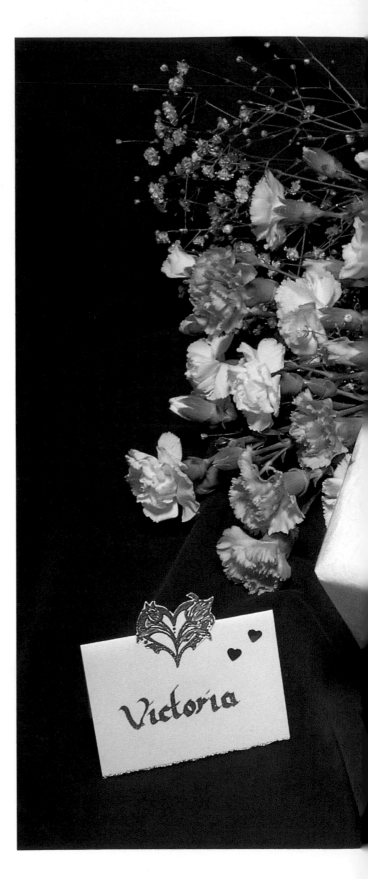

For these wedding items, emboss an elegant design in gold on mulberry paper and wrap up your present. Use double-ended brush pens to colour in the stamped images. Make the place cards by the cut-out method (see page 39) after stamping halfway over the fold. The names look lovely embossed too – use a calligraphy embossing pen (see page 31). You could also make invitations, and emboss and colour in paper napkins to match the set.

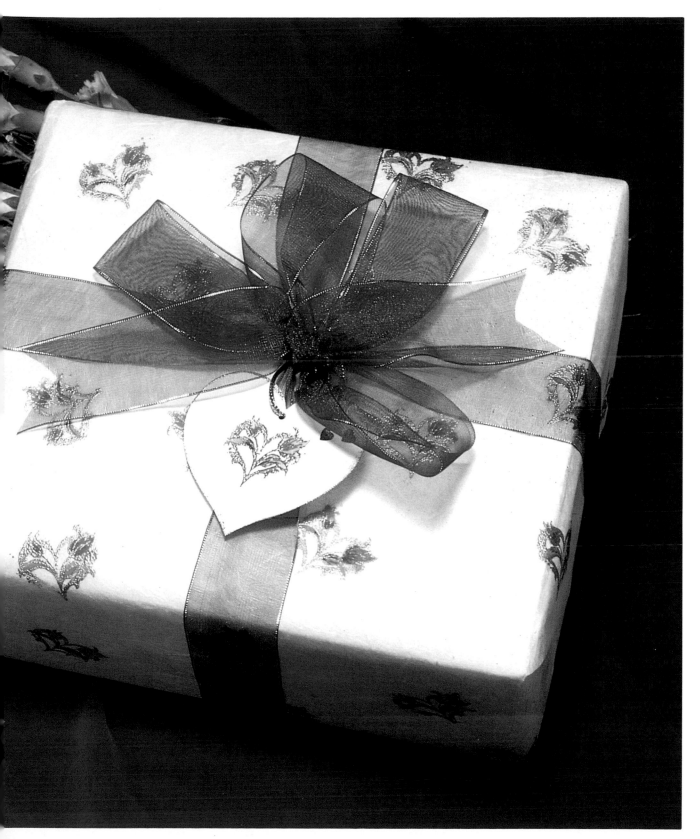

The history of the rubber stamp

Prior to the rubber stamp, there were metal printing stamps, usually made of brass. These preceded the rubber version by six to eight years. We remember them in the form of seals, used with wax to ensure the privacy of documents. The seals themselves were generally very elaborate. The word 'stamp' is used to refer to a marking device.

There is some confusion surrounding the production of the first rubber stamp. In America, Charles Goodyear discovered the process by which rubber is cured in 1844, while he was experimenting in his kitchen. He dropped a mixture of rubber and sulphur on to a hot stove and found that it was still flexible the next day. The process was dubbed vulcanisation after Vulcan, the Roman god of fire.

The birth of the rubber stamp was closely entwined with early dentistry. Vulcanised rubber, set in plaster moulds, was used to make cost-effective denture bases. Dentists had their own round vulcanisers, called 'dental pots', which would be used, eventually, to manufacture the first rubber stamps.

In 1866 James C. Woodruff started experimenting with a vulcaniser, trying to make some letter moulds. He asked his uncle, who was a dentist, for help and advice and after additional experiments with the 'dental pot', the first quality rubber stamps were created. Some of the rubber stamp companies formed in 1880 are still in business today.

The rubber stamps we are familiar with are those found in banks and offices, such as the mechanical date stamp, and in the Post Office.

The first picture stamps came in the form of educational stamps. German artist Kurt Schwatting, as early as 1919, used artistic stamps in his collages. The home of 'art stamps', as they are often called, is California, where they have been popular for over sixteen years, and there are specialist shops just selling art stamps. With the increase in workshops and demonstrations over the last few years, the craft has grown tremendously.

Some truly wonderful effects are achievable with art stamps, both by those who are creative and those who are not.

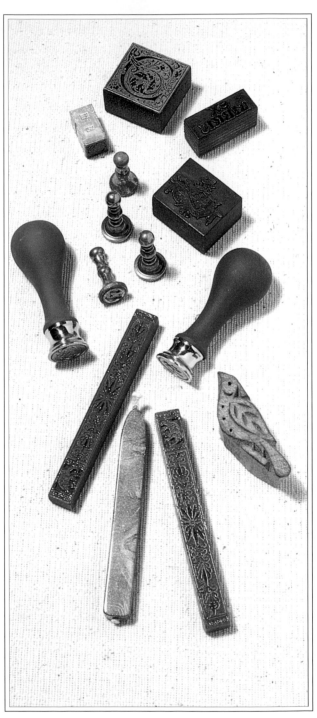

Some forerunners of the rubber stamp: seals, woodblocks, printer's blocks.

Getting started

Every stamp has its own character. You probably think I am mad, but you will know what I mean in time, when you have used various stamps. For a smaller stamp, light pressure is needed when stamping, but for larger stamps, greater pressure is required.

Always ensure that you stamp on a flat surface. When using a rubber stamp for the first time, stamp on to scrap paper first, as many stamps may have a coating of chalk left on them from manufacture. This also enables you to get to know the stamp and saves wasting card.

Before you start stamping, set up your work area. There is nothing more annoying than having to get up and down for things that you have forgotten. Protect your table from inks with paper, or work on a large pad of plain or coloured paper. This is handy for stamping first images or experimenting with design. It also gives you a flat surface to stamp on.

When stamping, I always have an old towel draped across my knees. This not only protects my clothes but also means that I can dab my stamps to ensure they are really dry, and wipe my hands too. To remove ink from your fingers, there are cleaning bars available.

When you are starting out, it can be difficult to know what to buy. In the following pages I have introduced the materials the first time you use them for a particular technique, rather than having them all in one great wadge, and I tell you what the products actually do, to help make choosing clearer.

Of course, you do not need all of it right away. Just start with the basics shown in the photograph.

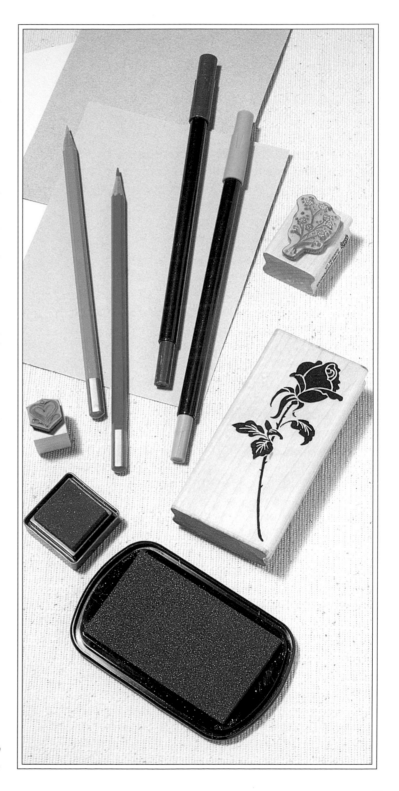

The basics of rubber stamping – stamps, stamp pads, brush markers, paper or card, pencils.

Paper and card

Most flat surfaces are stampable if you use the right ink and technique, but paper and card, in all their infinite varieties, are the obvious first choice.

Remember to practise a design on a piece of scrap paper first to avoid waste.

PAPER

This comes in many forms, shapes and sizes – the choice is endless. Make your own personalised stationery, decorate your envelopes, or create stunning gift wrap. Brown paper is great to stamp on. It is cheap and effective and gives a fashionable recycled look. Or stamp tissue paper to match your wrapping paper, to wrap up fragile presents.

Some helpful hints: papers with a glossy finish are best used with dye-based stamp pads and marker pens for vibrant colours. Papers with a matt finish are best for soft colours and for use with coloured pencils and embossing. Recycled papers come in wonderful soft beiges, greens and browns. Dark papers give a dramatic look: emboss on them in white or metallic colours, or use pigment ink. You can also stamp on mulberry paper.

Watercolour papers are ideal for coloured pencils and for aquarelle (water-soluble) pencils, as when you apply water with a brush the paper will not 'cockle' or warp.

Most companies supply a range of papers to correspond with their stamp designs, and you can also buy a wide range of paper in art shops.

Sticker sheets, with their self-adhesive backing, are great for making good any mistakes. They can also be used for stamping images which you then cut round and apply to any background.

CARD

There is a wide range of white and coloured card available, matt or glossy. Make birthday, Valentine, Easter and Christmas cards, gift tags, invitations for weddings and parties, birth announcements and moving-house announcements, or design your own special gift tags to match gift paper. If one type of card is not suitable for actually stamping on, it may make a good mount, so do not reject anything without thinking about the possibilities first!

OTHER SURFACES

You can also stamp on wood, fabric, papier mâché... experiment a little!

Stamping terms

Cushion This is a foam material found between the mount and the rubber die.

Decal Label indicating the stamp image.

Die This is the part which prints the image: it is made of rubber and is attached to the cushion.

Embossing The technique of applying powder to an image you have stamped and then heating the powder, which melts, hardens and gives a raised, embossed finish.

Fading This is when you repeat stamping without re-inking (to give a 'distant' effect).

Image The impression left when you stamp.

Masking A technique to let you make an image appear in front of or behind another image.

Mount Wooden block on which the die is glued, usually made of a hard wood, *e.g.* maple.

Pop-up cards When you open a card, your image will 'pop out' at you because of the way you have cut and glued it to the card.

Repetition When you use one stamp and repeat the design over and over again.

3-D effects A way of adding dimension to your card by layering cut-out images.

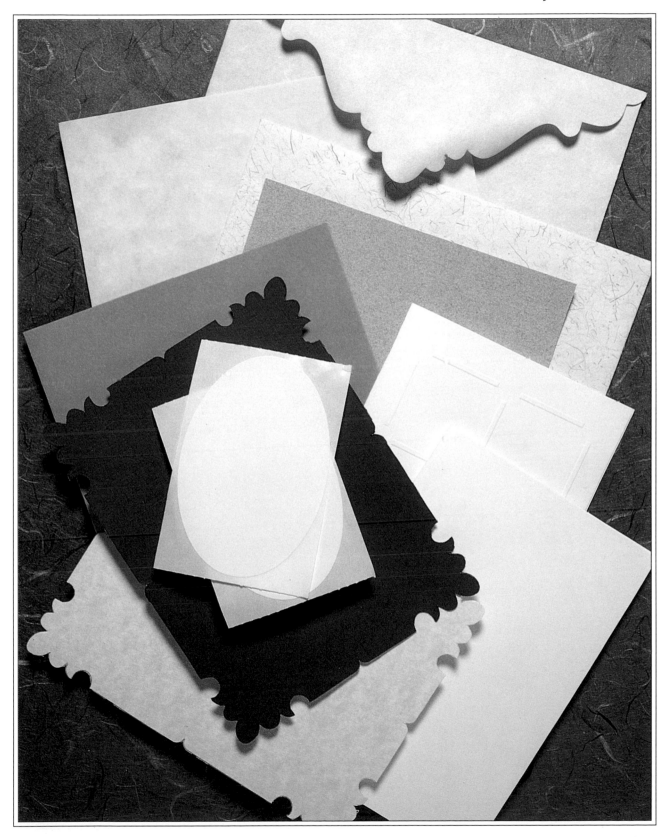

About rubber stamps

There are two main types of rubber-stamps: 'fine-line' and solid.

Solid-image stamps print images that are solid rather than in outline, so they cannot be coloured in as fine-line ones can, but they will be bold and colourful if used with dye-based pads or colour markers. A multi-coloured image can be created by using brush markers directly on to the rubber die itself (see pages 19–23).

Fine-line stamps, on which the design is in outline, can easily be coloured in after stamping. Fine-line stamps are ideal for the embossing technique, which raises a stamped image and allows easy colouring within the design.

Whether you choose stamps with handles, wooden blocks or foam-rubber backing depends on your taste and budget. Wooden blocks tend to be easier to hold and use, and look attractive, but cost more.

There must be thousands of different designs available: pictorial ones such as animals, flowers and trees; message stamps such as 'Merry Christmas'; letters of the alphabet – as monograms for stamping personalised paper or as whole alphabets to stamp your own messages, names, etc.; special stamps for bookplates, invitations, jam labels, or 'handmade by' labels to sew into hand-knitted clothes; stamps for borders and frames . . . from large blocks that fill your hand to tiny ones the size of your little fingernail. Something for every taste!

Remember, a bit of lateral thinking can give you extra creative value from some of your stamps. Try turning one upside down for a completely different look. One way up, using blue ink, a stamp could be a spire of delphiniums, but the other way up, with mauve ink, it could be a raceme of wisteria hanging down!

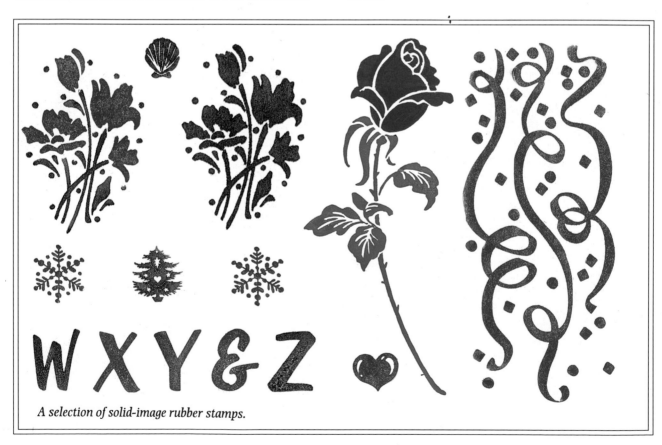

A selection of solid-image rubber stamps.

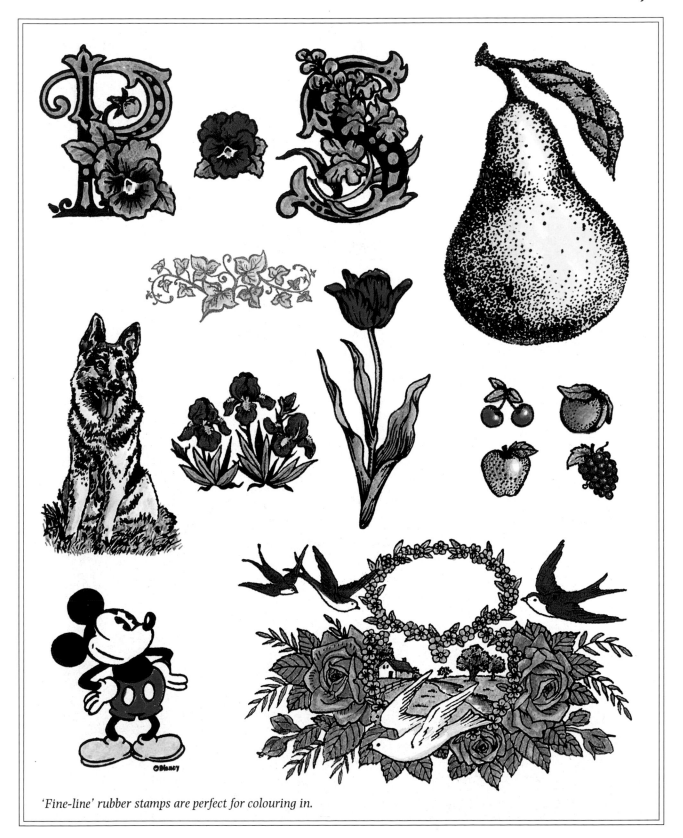

'Fine-line' rubber stamps are perfect for colouring in.

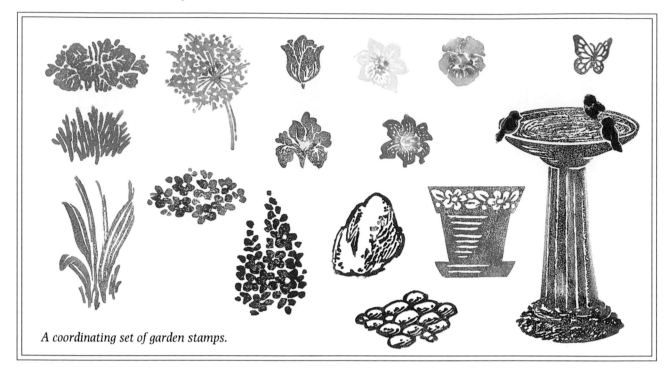

A coordinating set of garden stamps.

Coordinating sets

Rubber stamp sets (ideal to get children started) are an inexpensive way of building up a range of stamps. The sets come with their deeply etched designs mounted on foam rubber, with colour stickers which you apply to the top of the stamp yourself to identify them (this keeps the price down as it is cheaper than mounting them on wooden blocks). There are themed sets, such as cats or music, or miscellaneous collections of mini-stamps, or co-ordinating sets that can be used to create whole pictures – for example, separate stems, leaves, and flower-heads which you can combine in dozens of different ways.

Using the set of stamps above, you can make imaginative pictures by adding different flower-heads to the same leafy base, or by building up a whole border of flowers. Try making a lawn by stamping repeated grass motifs, or filling the bird-bath with a cascade of blooms by using the masking technique (see pages 32–35). (In the picture on the right, a mask was used on the bird-bath.)

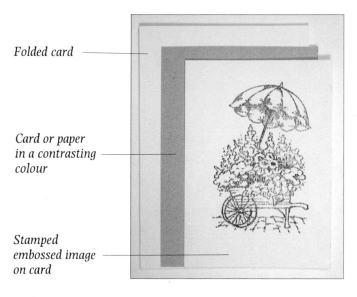

Folded card

Card or paper
in a contrasting
colour

Stamped
embossed image
on card

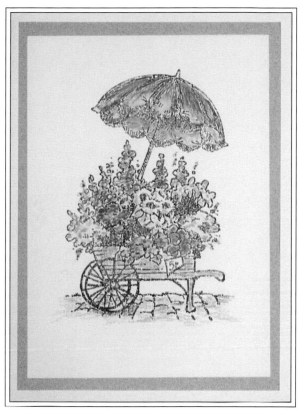

Mounting

Choosing the right mount is the finishing touch: it lends your card a professional look. It also gives you more flexibility, as small designs can be made to fill a larger card, and if you have made a mistake you can cut out the successful part of a design and mount this on to a fresh card – this saves wasting the whole card.

Make a double mount, or a single one, using colours of card and paper that tone with the colours of your design. Corrugated card has a fashionable natural look; while mulberry paper with its attractive fibres is very tasteful and also can be torn to make a decorative edge (wet it down the edge and tease it away with a fingernail to give you a nice frayed edge); or use fancy-edged scissors to make a different look – wavy, zig-zag, deckle-edge... You can also use fabric (cut it and mould it around some scrap card, then mount this on to your working card), gift wrap, or glitzy vinyl-type paper.

You could emboss round the edge of a card, or use glitter glue; add a ribbon trim to a special card, or a bow, or some raffia.

This useful and stylish folder is easy to make from covered card, with three related mounted designs glued to the cover and raffia added to fasten it. You could also use ribbon, or even shoelaces.

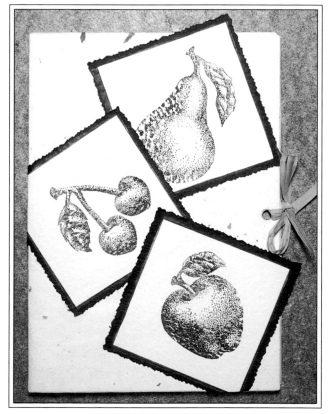

Using stamps on stamp pads

Dye-based stamp pads are quick and easy to use and you can create multiple images fast. You can equally well use pigment-based pads.

STAMP

You can use either outline stamps or bold-image stamps for this technique. Here I have used an outline stamp so that I can colour the finished image in with coloured pencils.

STAMP PAD (DYE-BASED)

This enables you to build up fast repetitive designs. It can also be used for the sponging technique.

Pads are available in a range of sizes, or in raised cubes which allow you to use them with any size of stamp, in an exciting range of colours. Use on glossy paper to get a professional and vibrant look. There are also dye-based rainbow pads, which give multi-coloured prints on one design. Store these level and in the refrigerator.

STAMP PAD (PIGMENT-BASED)

This has a somewhat denser colour and also can be used for embossing, as the ink stays wet longer than a dye-based ink, allowing you time to apply embossing powder. Pigment stamp pads, which come in a variety of pads or cubes and a wide range of vibrant colours, can be used on their own on absorbent paper. In a multi-coloured pad the inks do not bleed into each other, and the pads can be cleaned by rubbing with dry kitchen roll.

Note that if you use this ink on paper or card with a glossy surface, it will never dry unless you emboss it.

COLOURED PENCILS

You can use coloured pencils to colour in details of stamped outline images. Try watercolour pencils, too – you soften and dissolve the colours with water and a brush – and watercolour paper, which is very heavy and card-like.

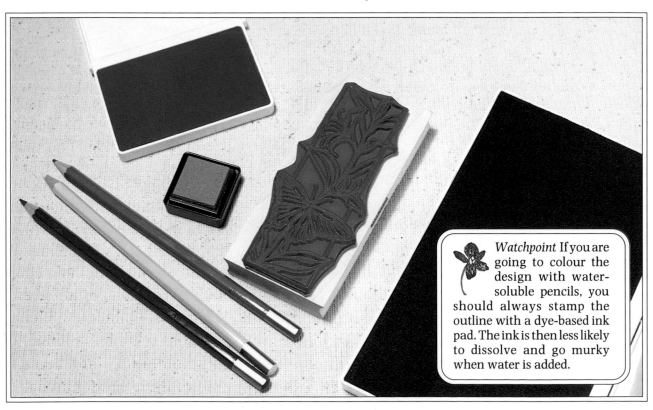

Watchpoint If you are going to colour the design with water-soluble pencils, you should always stamp the outline with a dye-based ink pad. The ink is then less likely to dissolve and go murky when water is added.

Step-by-step

1. Take your stamp and, holding the mount firmly, press the stamp on the ink pad several times.

2. Turn the rubber to face you and check that the entire surface of the rubber glistens. If it does not, press it on the pad again.

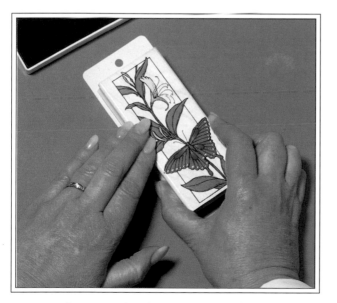

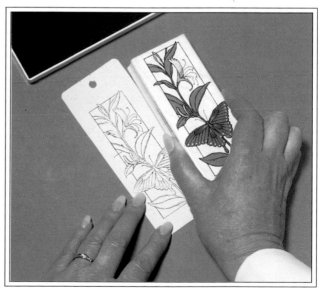

3. Press the stamp firmly on to your paper or card on a flat surface, holding the paper still when lifting off the stamp. Do not rock the stamp or the image will be blurred.

4. The result is a clean, clear image.

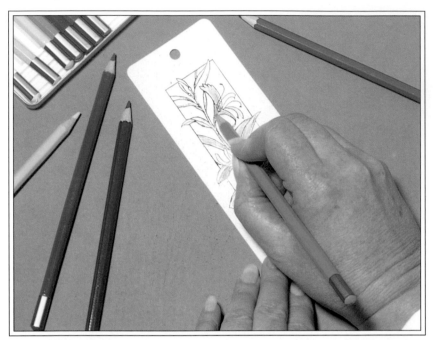

5. Clean the stamp carefully (see page 47). Now simply colour in details of the design with brush markers or coloured pencils, mixing and blending colours to add a sense of dimension. Here I have used recycled card and coloured pencils to get a soft, subtle look. For a different look, you could equally well colour in the design with brush markers, which would give you rather bolder colours, more like those on the decal of the rubber stamp.

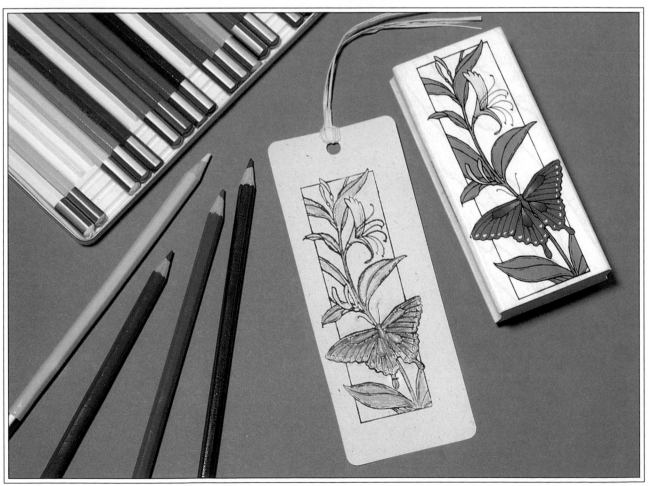

Repeat stamping

Stamping with a dye-based ink pad on glossy paper gives a vibrant look.

Stamp your message, then repeat the stamp twice more to build up a card. Now take coordinating double-ended felt-tipped pens and draw thick and thin lines alternately, using a ruler.

Finish the card off by adding two more small stamped designs as decoration.

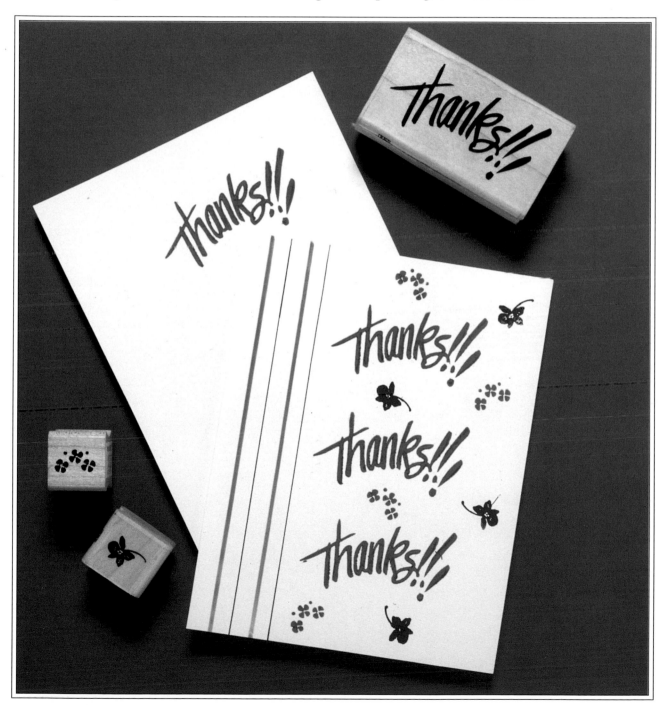

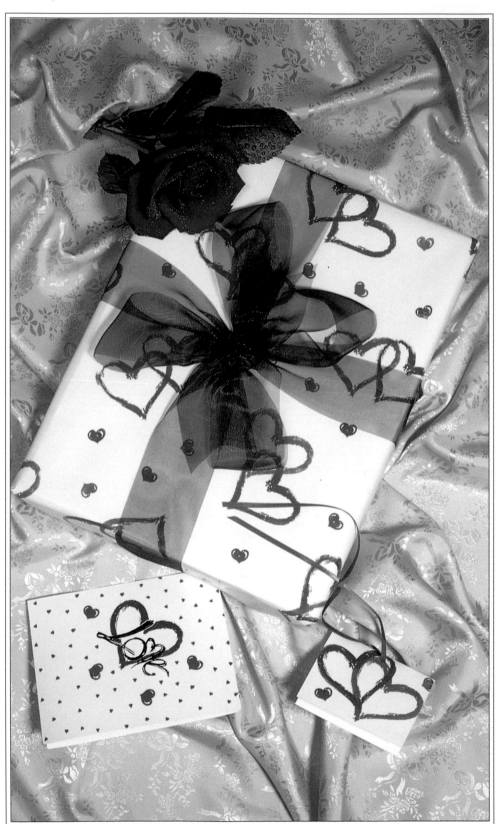

Valentine theme

For this project, use dye-based stamp pads in two different shades of pink. To decorate the present, stamp hearts at random on a sheet of glossy white wrapping paper and then add a matching tag. For the card, simply stamp the design – hearts and 'Love' – on glossy card using stamp pads. You could get a very similar result using brush markers directly on to the die – read on and find out how.

Using brush markers on stamps

These water-based brush pens with a generous flow of ink are a great way to get colour just where you want it. They cover a solid image fast and also give you the versatility to apply more than one colour to each stamp, so that you can create multi-coloured images.

BRUSH FELT-TIPPED PENS

Brush markers are very useful, both for colouring in stamped images and for using directly on to the die. If, when colouring in a large stamp in several colours to get a multi-coloured image, the first ink has dried by the time you are ready to stamp, simply breathe on the rubber to redampen it before you stamp.

Use them on glossy paper to get a professional and vibrant look, or on recycled paper (with sepia-coloured ink) for a nostalgic Victorian look.

Using brush pens makes your stamps useful in many ways: for example, if you have a stamp with both a picture and some text on it, you can just use the text part, or vice versa. (Always ensure your stamp is really clean when using this technique.)

You can also get double-ended brush marker pens. These are good for colouring in the designs after you have stamped your outline, either embossed or stamped with a dye-based pad. The fine and medium points allow you to colour in the smallest of areas. Use water-based pens, *never* permanent pens, as these will ruin your stamps.

STAMP

Use a bold-image stamp for this technique rather than an outline stamp.

Step-by-step

1. Use a brush marker directly on to the rubber to colour the stamp.

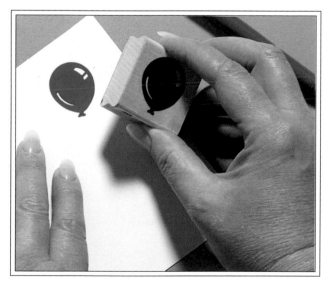

2. Stamp out your image, holding the paper still when lifting the stamp off. Clean the stamp (see page 47 for the best way to do this).

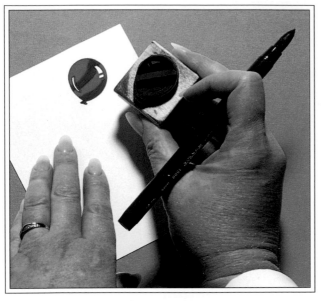

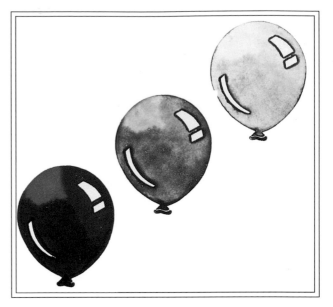

3. Now try two markers, using colours that go well together and making sure that you use the lighter-coloured pen *first* in order to keep its tip clean. Breathe on the stamp to remoisten the inks before stamping. Finally, clean the stamp again.

You could also try using three colours on the rubber.

Variation Try the fade-out technique. Without cleaning the stamp, stamp three more times and see the different looks you can achieve as the image gets paler and paler. If you do this in the background of a picture, the palest balloon will look as if it is floating into the distance.

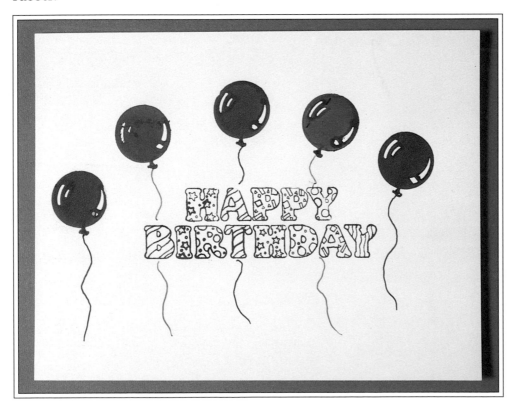

To make this simple birthday card, I highlighted a 'Happy Birthday' stamp with brush markers in two different colours and stamped some balloons to coordinate with the message. Then I drew strings attached to the balloons, using the fine-tipped end of the markers in two alternating colours.

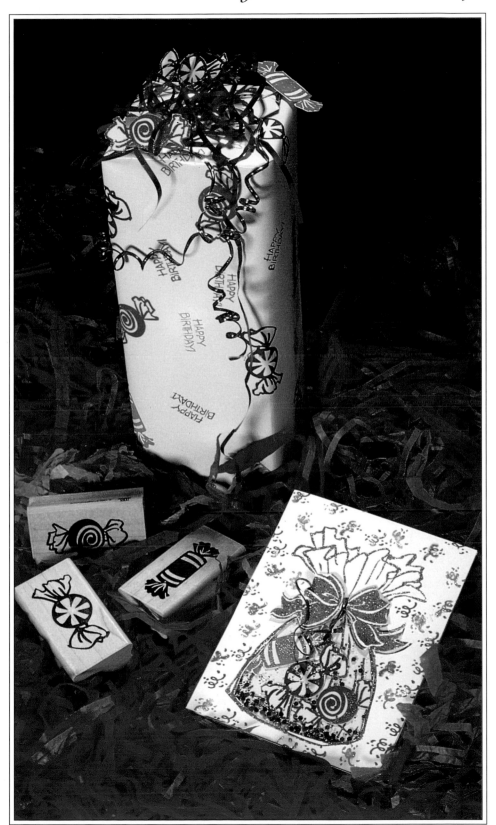

Birthday present and card

For the birthday present with its 'sweetie' theme, use different coloured brush markers on the die and stamp the design all over a sheet of glossy wrapping paper. Stamp the sweet image on to card, cut it out and use it as a gift tag. Finish the parcel off by decorating it with wired ribbon, wrapped around a pencil to give a concertina effect. To make the card, use a three-way card and stamp the bag stamp on the middle section. Then cut out the inside of the bag and use acetate to form a window bag. Fold the front flap back and glue it in place to hide the back of the acetate bag after enclosing some sweet images which you have stamped and cut out. Decorate the outside with streamer stamps and glitter.

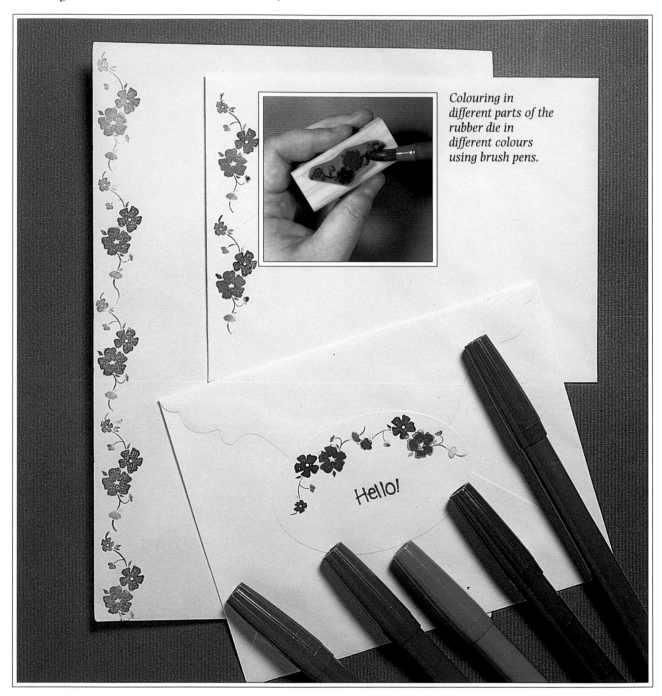

Colouring in different parts of the rubber die in different colours using brush pens.

Colouring in different parts of the die

To create this pretty border, colour the flowers on the die using brush markers in different colours. Similarly, brush in the leaves and stems in green. Then simply breathe on the rubber and stamp your multi-coloured image on writing paper, envelopes, self-adhesive seals, etc. to create a matching set. Then, using the fine tip of a double-ended pen in a colour that goes with your stamped designs, write your letter and address your envelope. Black and blue biros are so boring!

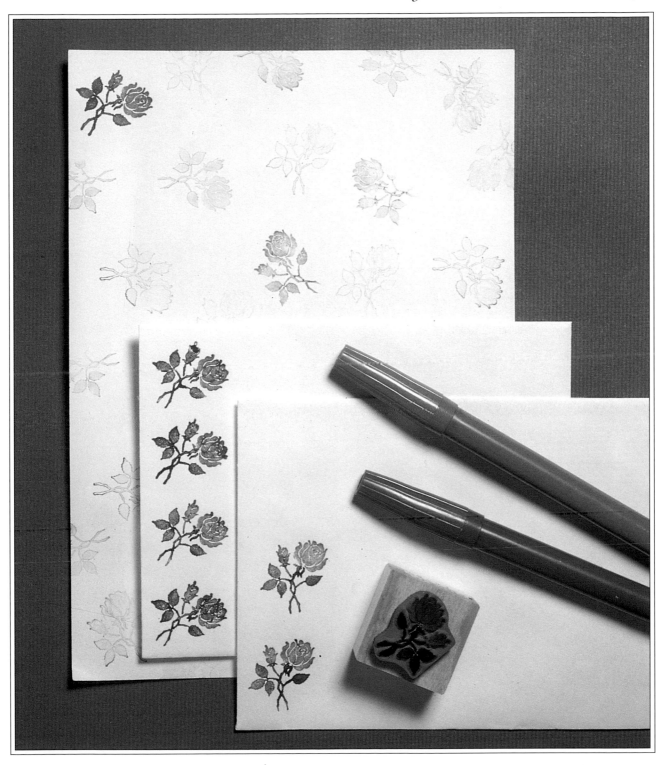

The two-tone roses on this writing paper were stamped once at full strength in the corner of the paper and then again in the fade-out technique (stamp off the first impression on scrap paper to make subsequent stampings pale) all over the sheet. This means that you can write over the images. A matching envelope is easily made.

Embossing

Try the embossing technique for a really professional finish. Embossing gives you a raised, shiny image when the powder is melted, which looks lovely. (It also helps stop you going over the edges when you are colouring in your image!)

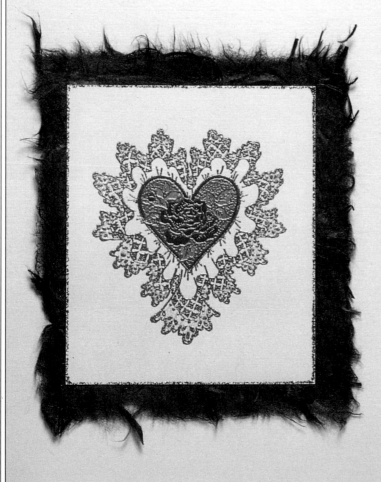

Embossing can look really spectacular, especially when using metallic colours such as gold and silver.

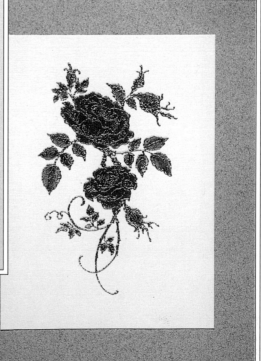

The first stage is to use an ink which when stamped out will remain wet long enough for you to sprinkle embossing powder on: that is, either special embossing ink or slow-drying pigment ink.

Empty any colour of embossing powder which you use very frequently (*e.g.* gold) into larger plastic containers, such as ice-cream tubs. This saves knocking it over and wasting it.

Get a different look to the same solid-image stamp by using different metallic embossing powders.

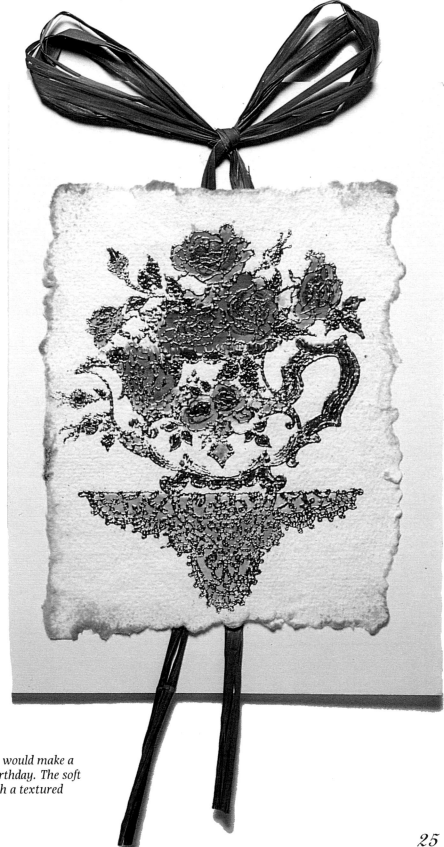

This pretty card with its embossed roses would make a lovely card for Mother's Day, or for a birthday. The soft pink border has been lightly sponged with a textured sponge dabbed on a stamp pad.

25

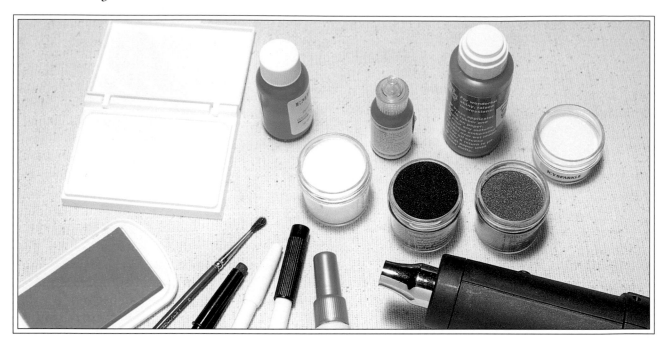

EMBOSSING POWDERS

These are used in conjunction with embossing pads or pigment inks and come in a wide range of colours and effects, including clear and pearlised (which have to be used with a colour, not with transparent embossing ink).

. Try using different base colours, giving endless possibilities.

EMBOSSING PAD AND INK

You can either buy the embossing pad already inked or you can apply the embossing ink to a lint pad yourself.

If you keep it stored upside down, it will always be ready for use. This ink stays wet when stamped to allow you time to sprinkle embossing powder on to the image.

Pads are available slightly tinted – pale pink or pale blue – just enough that you can see where you stamped your image, to enable you to sprinkle the embossing powder in the right place. Otherwise all images are invisible!

EMBOSSING INK BOTTLE

This comes with an applicator top. You can either apply the ink directly to your stamp with it or use it to emboss the edges of paper and card.

PAINTBRUSH

You will need a fine paintbrush to whisk away unwanted specks of embossing powder from your image before applying heat.

EMBOSSING PENS

These contain slow-drying ink, which allows you to emboss whatever you are writing or drawing. They are available in ballpoint-pen form or with a chisel-shaped felt tip for calligraphy.

HEAT GUN

This, which blows very hot air, is one of the safest forms of heat source for melting your embossing powder, and is certainly the quickest, easiest and most convenient. You can buy heat guns specially for embossing work, or use the sort sold for paint-stripping. Alternatively, hold your work over a toaster or electric ring, powder side facing upwards, for about a minute, or in front of an iron or electric fire. Use a clothes peg to hold the card to save toasting your fingers as well. Be careful not to overheat your work or the embossed image will go flat and dull – it should not bubble when heated.

Important: the metal nozzle of the gun reaches a very high temperature and can burn you if you touch it, so always supervise children's embossing.

Step-by-step

1. Stamp on to the pad with a dabbing action.

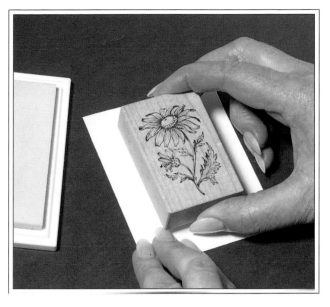

2. Then press the stamp firmly on to the paper.

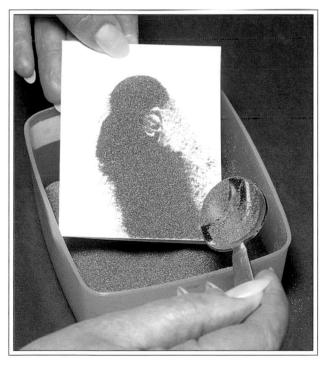

3. Generously sprinkle gold embossing powder over the wet image, using a teaspoon.

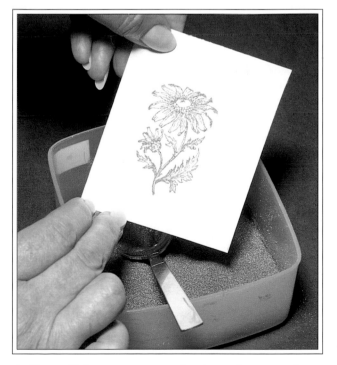

4. Tap off the excess powder into the container. (Alternatively, tap it on to folded paper and return it to the bottle.) The powder will adhere to the wet ink.

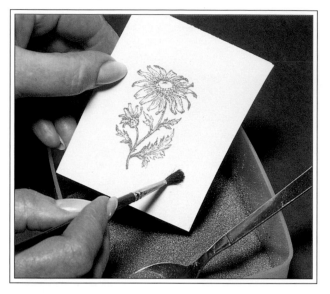

5. Brush any odd specks away with a fine dry paintbrush or they will also get embossed and spoil the look of your work.

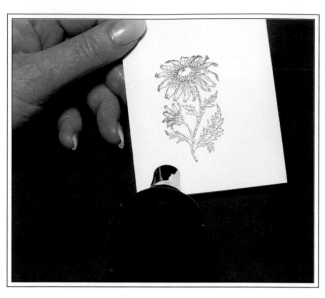

6. Now heat the image, using a heat gun to melt the powder evenly by playing the nozzle back and forth across the image until the powder melts and the image appears raised and shiny. If you overheat the powder, the embossing will dull.

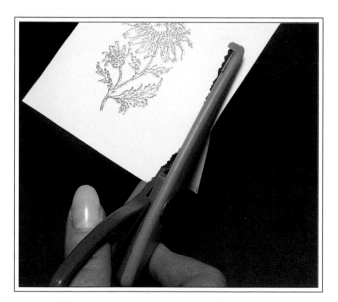

7. Use deckle-edged craft scissors to cut a fancy edge along the front of the outer edge of the card.

Fun scissors have special blades, like pinking shears, that allow you to cut different types of decorative and wavy edges to your card. Deckle edges, for example, give an old-fashioned look and finish off a Victorian-style card.

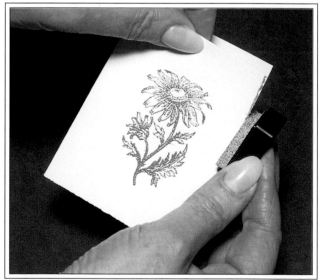

8. Take a gold pigment cube and run it down the edge.

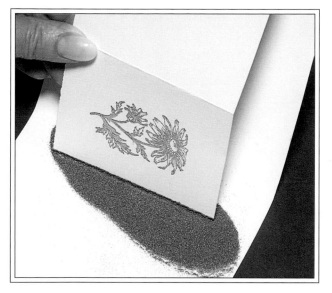

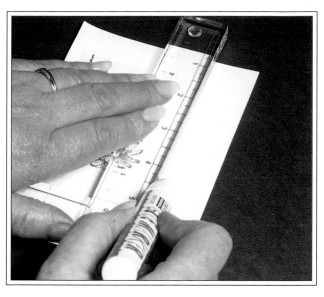

9. Now dip it into embossing powder which you have tipped on to a piece of folded card or paper. Tap off the excess and heat along the edge only. This will give you a golden edge.

10. Use an embossing calligraphy pen or glue pen to draw a straight line down the folded edge and emboss this with gold to add the finishing touch to this card.

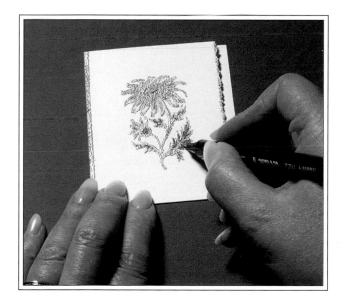

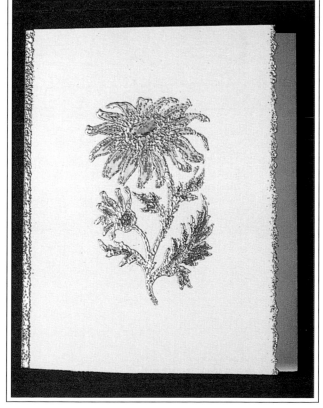

11. Finally, using your fine-tip pens, colour in the images, blending and toning the colours well to give a realistic look.

The finished card.

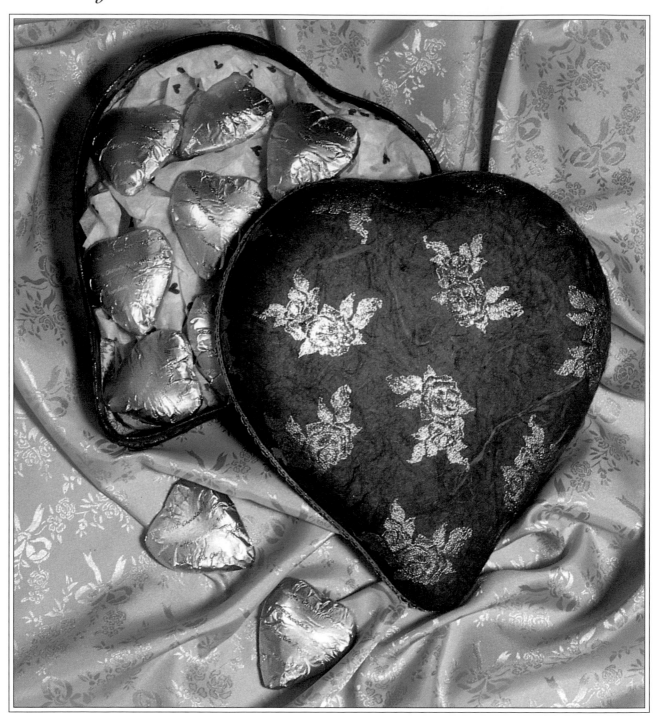

Gift box

I bought a heart-shaped box to present some gold heart-shaped chocolates, and decided to decorate it with some embossing. First of all I stamped and embossed an all-over design on burgundy mulberry paper and used it to cover the box (I put the glue on the box, not the paper). Then I glued on a length of gold braid all round to hide the edge of the paper. Tissue-paper with little burgundy hearts on it was the finishing touch.

EMBOSSING USING CLEAR POWDER

Stamp images with colour pigment cubes, using a dabbing action, adding more than one colour if you wish. Stamp out the image and sprinkle it with clear embossing powder, then heat it until the image looks wet and glossy. Black colour cube under clear powder looks good, and really makes message stamps stand out.

Embossing with clear powder over black colour cube.

Do not be afraid to experiment by mixing base colours with different coloured powders. You can also introduce several different colour powders to one image, *e.g.* gold, silver, copper, by being very careful where you sprinkle the powders on the wet image.

> 🌸 *Watchpoint* Always check the back of your card for embossing powder before heating. Any loose specks will emboss and look unsightly. Always work with well-washed hands and handle the paper and card as little as possible, as any moisture or grease on your skin will make the powder stick to the card where it is not needed.
>
> Practice makes perfect!

Experiment with different cards and powders: for example, white embossing powder on a black card stands out very boldly, whereas white embossing on a cream card has a very subtle look – totally different.

The dramatic look of white embossing on black card.

USING EMBOSSING PENS

You can personalise a letter or add lettering to a greetings card using an embossing pen, which contains slow-drying ink. Simply sprinkle powder on to wet writing (you will probably be able to do several words at a time) and heat in the same way as shown in the embossing demonstration. You can draw with the pen too, or fill in gaps on embossed work. Calligraphy looks wonderful when embossed, so try out a calligraphy embossing pen – the principle is just the same.

Remember to work with a spare piece of paper under your hand to stop any moisture or oil on your hand being rubbed on to the paper.

Embossing pen

Calligraphy pen

Using masks

Masking is a technique that allows you to overlap images, so that one image appears to be behind the other.

It is quite easy. Just remember: make a mask of the image you want to be in the foreground. If you want, say, to fill a vase with flowers, mask the vase and then stamp flower images. When the mask is removed the stems will look as if they are in the vase.

POST-IT NOTES

To make a self-adhesive mask, use ordinary post-it notes.

A selection of masks.

Step-by-step

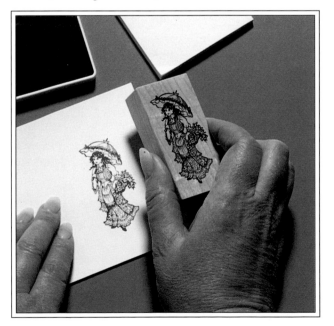

1. Stamp the foreground image (*i.e.* the Victorian lady) first.

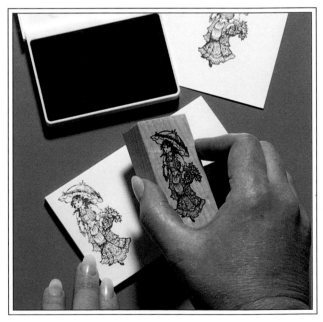

2. Then stamp your second image on a post-it note as near to the top of the note as possible, so that some of your stamp image is on the part of the note that has the self-adhesive backing.

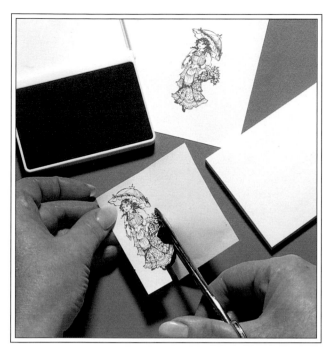

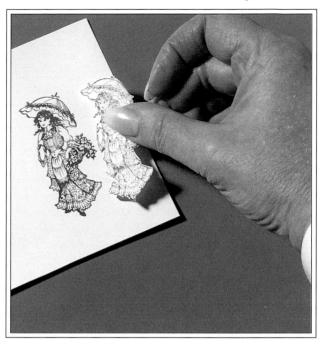

3. Carefully cut out the image, keeping just outside the outline. (This cut-out image on the post-it note is called your mask.)

4. Place the mask directly over the stamped image (the lady).

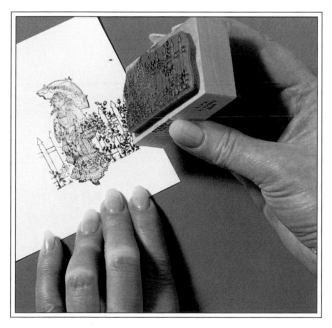

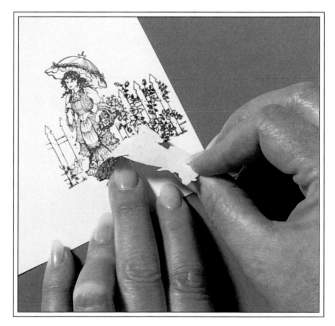

5. Ink the stamp you wish to appear behind the image (*i.e.* the fence) and stamp on to the card, *across* the mask.

6. Remove the mask and the fence now appears to be behind the lady.

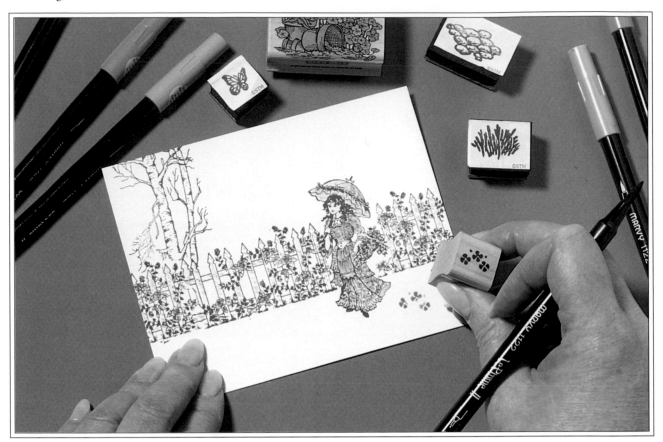

7. Make a mask of the fence and stamp a tree. The tree now appears to be behind the fence. Start to stamp in flowers using brush markers, and colour in the roses on the fence.

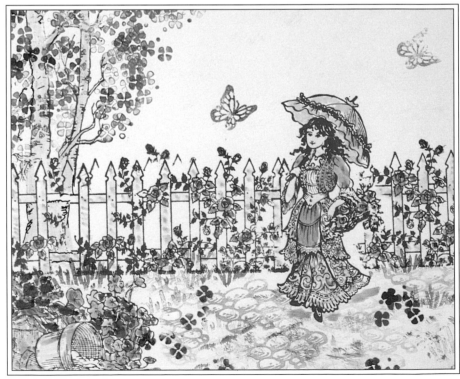

8. Carry on building up the picture with different stamps – flowers, butterflies, clover, cobbles and grass – in a similar scale. (This is where a set of small coordinating stamps can be very useful.) Finish colouring the card.

Another simple masking project

To make this easy but effective card, I used a teddy-bear stamp on a purple and pink rainbow pad. I then masked the image and repeated the stamp, then finished the card off by making cardboard mounts and decorating it with raffia.

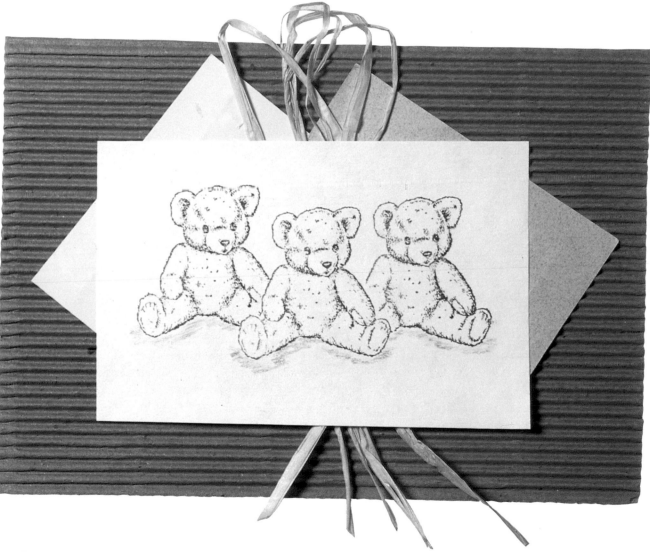

 Watchpoint Masks take a long time to cut out, so they are worth keeping for future use. Make a folder and keep them in there. For your reference, stamp the images that you keep there on to a sheet of paper and when you put in another mask, stamp it on the sheet. This gives you an up-to-date catalogue of what you have.

Positioning stamped images

Positioning your stamps using a stamp aligner allows you to stamp your image exactly where you want it. The stamp aligner will also allow you to restamp a correction (if perhaps you missed inking a bit of the die), to over-stamp for special effects, or to stamp a perfect border.

STAMP ALIGNER

This is a plastic T-square ruler which offers several methods of perfect stamp placement, helping you to align your images regularly. It is used in conjunction with tracing paper.

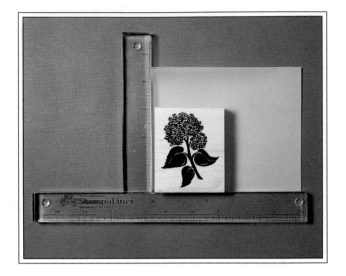

Step-by-step

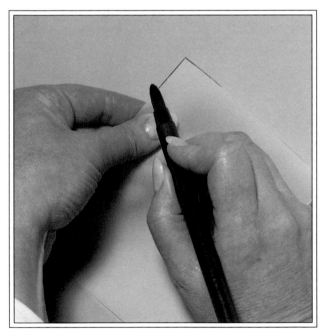

1. Take a sheet of tracing paper and run a felt tip down the edges of the top left corner and the bottom right corner. This lets you line up the paper with the stamp aligner easily and stops the paper sliding unnoticed under the aligner, as can easily happen.

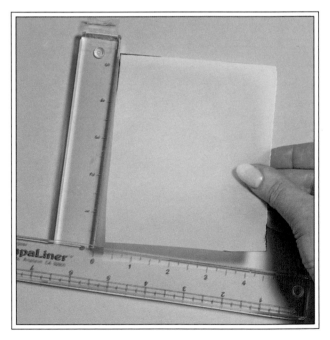

2. Place the sheet of tracing paper up against the right-angled corner of the stamp aligner.

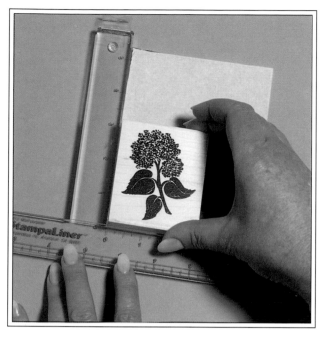

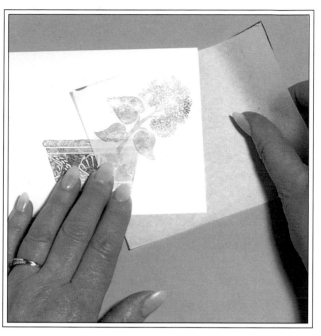

3. Now ink your stamp with a brush marker and stamp your image on to the tracing paper carefully by guiding the wooden block of the stamp into the right angle (or 'zero corner') of the stamp aligner.

4. Stamp a pot on your card, using brush markers, and cover it with a post-it-note mask. Now take the tracing-paper image, position it where you want to stamp, and hold it in place there.

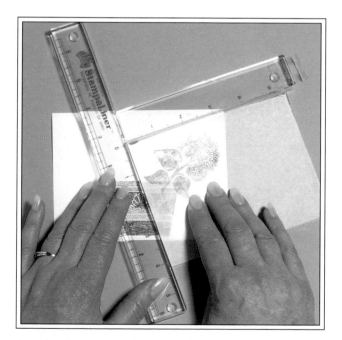

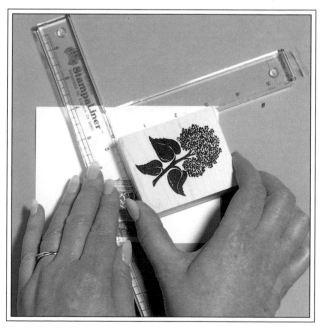

5. Take the stamp aligner and position it so that the tracing paper is back in the right-angled corner.

6. Hold the stamp aligner firmly in place and remove the tracing paper. Then guide your inked stamp into the right-angled corner and stamp your image.

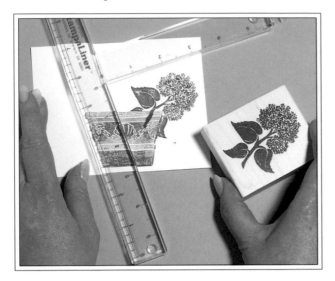

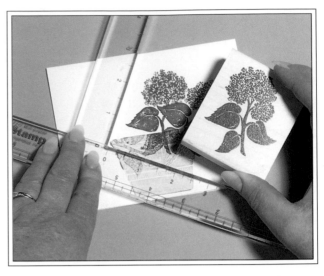

7 & 8. Continue to build up the picture in the same way. To finish the card, stamp a few leaves on glossy sticker paper, cut them out and stick them on the design for some realistic overlapping, then add a lightly sponged background and stamp a little grass.

The more distant hydrangeas were created by stamping without re-inking, to get a paler effect.

This technique may not sound as easy as some, but it is well worth while practising as it will give you some very professional-looking results.

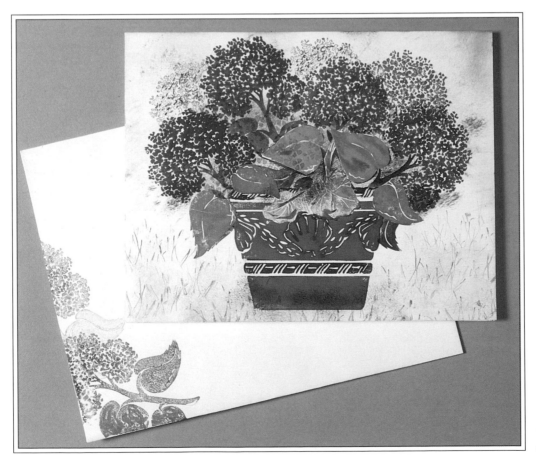

The finished card with a matching envelope.

Cut-outs

Using a craft knife, or scissors, you can cut out all or part of a stamped image for some unique effects.

CRAFT KNIFE
You will need a knife that has replaceable sharp, thin blades for making slits and cutting out intricate details. A scalpel would be just as good. Use in conjunction with a self-healing cutting mat to protect the knife edge and your working surface.

Step-by-step

1. For this place card, stamp the image halfway over the line along which you intend to fold the card, then emboss it as normal.

2. Colour in the image with brush pens. Now, with your craft knife or scalpel, carefully cut round the portion of the image that appears in the top half of the card.

3. Now simply fold the card in half horizontally and it is ready to put in place. Add a name in embossed calligraphy if you like.

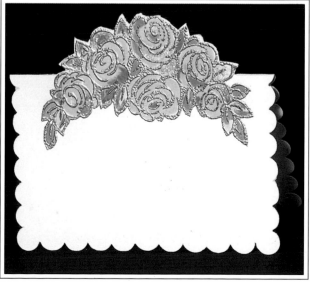

You can also stamp out a row of bold flowers or fruit along the edge of a card. With a sharp pair of scissors or a knife, cut along the outer edge of the image to form a line in the shape of the image. This creates a different and very attractive effect.

Three-dimensional cut-outs

This 3-D papercraft technique adds another dimension to your work. It is a variant of the well-known craft of 3-D découpage.

SCISSORS

Use small sharp scissors, or a craft knife and self-healing mat if you find this easier.

Step-by-step

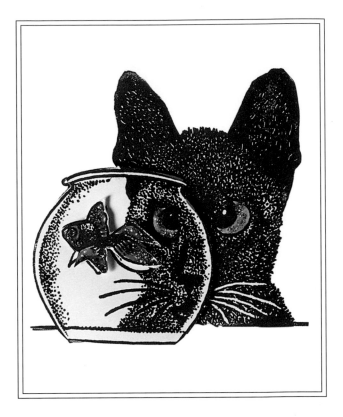

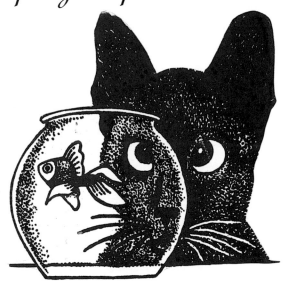

1. Stamp the entire image on to your card.

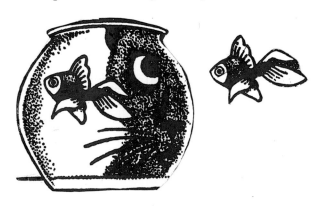

2. Stamp the image again on to two other pieces of spare card and cut out the parts of the design you will need: the fish bowl and then just the fish as well.

3. With a small piece of foam-backed double-sided tape, stick the fish bowl to your card, lining it up carefully on top of your first image. (Self-adhesive mirror-tile fix-its are also useful.) Now mount the cut-out fish on top of the image of the fish in the fish bowl, so that there are three layers altogether, each higher than the last.

To finish off the card, use orange glitter glue on the fish and green glitter glue for the cat's eyes. Allow an hour for this to dry. Then add lettering if you want, or stamp a message.

 Watchpoint For different scene dimensions, more layers can be added to vary the height, or you can thicken the mounts.

Glitter effects

A little glitter adds a touch of sparkle to your work – it will highlight designs and catch the light in the prettiest way.

GLITTER GLUE

Glitter glue comes in handy little squeezy bottles for mess-free application. Crystal-coloured glitter glue will give you the look of snow on the roofs of houses; red will bring out holly berries; and green will look like frost on your pine trees! There are many colours available. It does take a while to dry, so do not handle your work for at least an hour after applying the glue.

LOOSE GLITTER

Available in many colours, the most popular being 'prisma', this has to be used with a glue stick or glue pen. It gives wonderful sparkle and is indispensable for Christmas cards.

GLUE STICK OR GLUE PEN

Glue sticks can be used for embossing with embossing powder (giving thick lines) or for edging a card with gold. They are also one of the best ways to stick loose glitter to your work.

Using glitter

Use glitter glue straight from the bottle to highlight an area of your design, or for exact placement try a fine brush. Glitter glue takes about one hour to dry.

Using a glue pen and dry loose glitter is fast and needs no drying time. Dab glue where you need the glitter and sprinkle the glitter on. Tap the excess off on to a folded sheet of paper and return it to the jar.

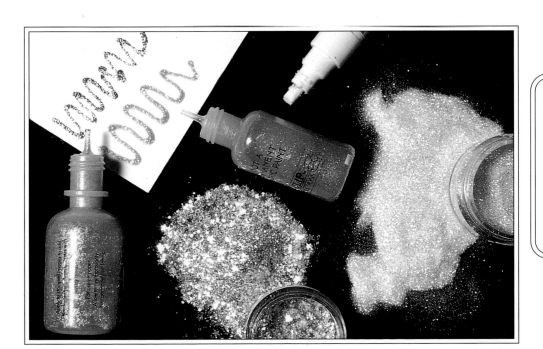

Watchpoint Glitter glue will make felt-tip ink run, so be careful where you apply it.

Sponging a border

Sponging makes a colourful decorative border for a card. The technique will also help create soft edges on white areas of a card that might otherwise look bare. Sponging can also create delicate backgrounds for you to stamp over.

SPONGES

There are many different shapes and textures of sponges, so experiment. As well as being perfect for striking borders, sponges are ideal for soft colour-blending techniques, *e.g.* delicate blue sponging for a sky.

Use them with dye-based stamp pads or brush markers.

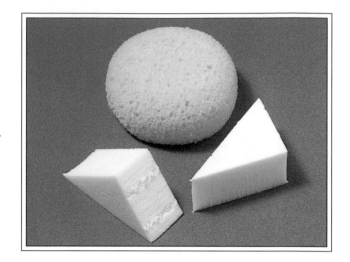

Step-by-step

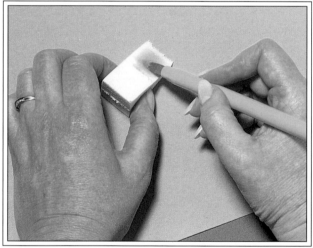

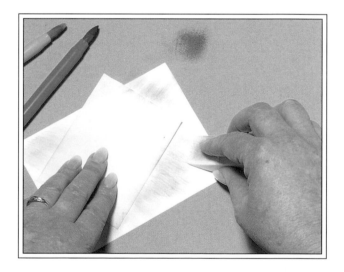

1. Here I have used a soft, smooth sponge of the type used for makeup.

Apply ink to the sponge, either from a stamp pad or from brush markers, then dab off the excess on scrap paper until you get the tone you want.

2. For this card, place a post-it note at an angle as a mask and then, drawing the strokes right off the edge of the card, apply first yellow, then pink, coral, lavender, and finally a light touch of purple. You could also dab on the colour, depending on the effect you want (see page 44). Here I have applied colour around the edges to make a border, but you could also use this technique for filling in a sky, or sponging to look like grass, applying darker green on the straight edge of the sponge to make blades of grass.

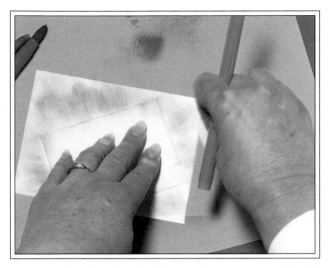

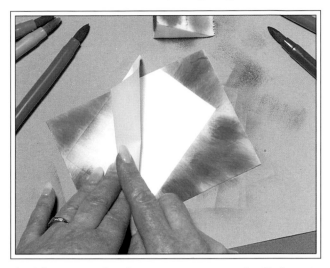

3. Do not be afraid to build up colours on top of each other. Keep sponging until you have the look you want – in this case rich and vibrant. A soft pastel look created with pale-coloured pens or pads would also look very pretty.

4. When you take the post-it-note mask off, there is a neat white panel in which to stamp a design of your choice. Alternatively, you could colour a message stamp with coordinating markers to match the colour scheme and stamp it in the centre of the panel, or write a message in it with an embossing pen and emboss it.

The finished card.

Combining techniques

Now that you have learnt all the basic techniques for rubber stamping, why not combine them to make some stunning projects for birthdays, parties, Christmas, etc.? Your friends will hardly believe that you did it all yourself!

Children's party

For this project, mask the central area of the invitation with a post-it note the edges of which you have cut with scallop-bladed scissors, and then sponge around the edge by pressing the sponge down so that its shape gets stamped on the card. Emboss Mickey Mouse and the message with a black colour cube and clear powder, using different colour cubes and clear embossing powder for the balloons. Colour in Mickey Mouse.

To make the place card, stamp halfway over a folded card and cut out carefully. Make the birthday card in the form of a pop-up card, with Mickey cut out and mounted on the top step.

Edge the steps and create fireworks in the background using glitter glue, then stamp *Happy Birthday* on a separate card. Edge it in gold to match the steps and glue it on to the base of the card.

To make a bag for children to take party goodies home in, use dye-based stamp pads to stamp all over plain brown bags. Stamp a name tag to match.

Another good idea is to use a disposable paper tablecloth and let the children stamp their own place setting on it. They love it!

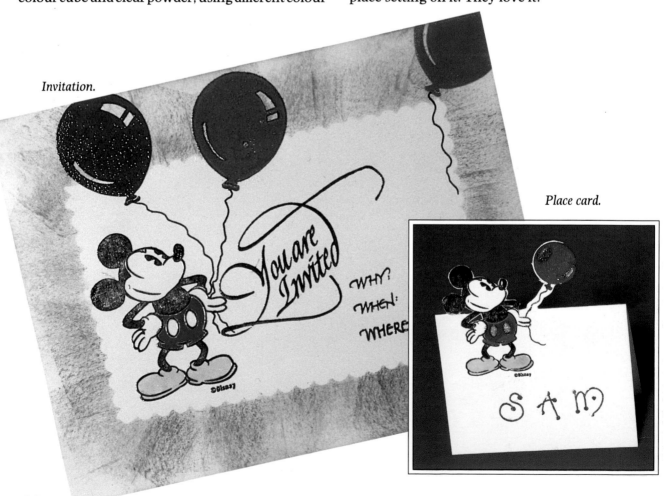

Invitation.

Place card.

44

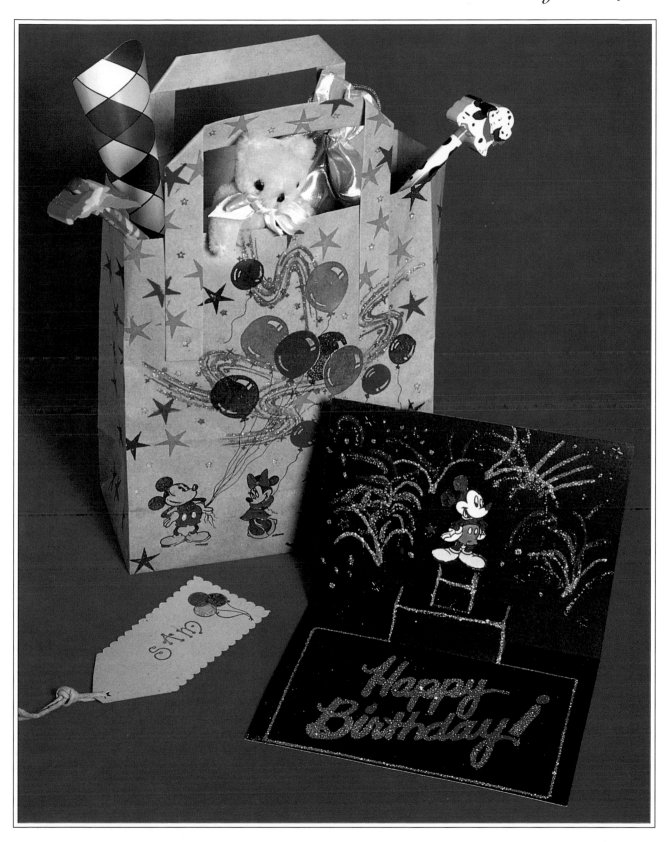

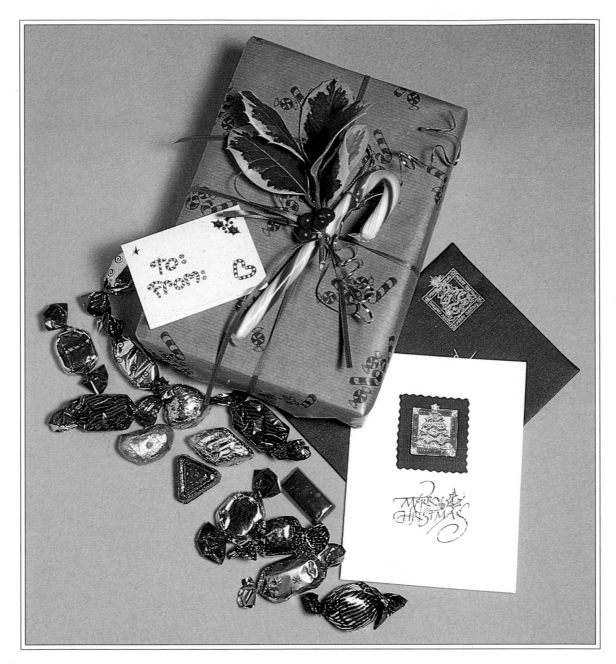

Christmas theme

For this project, use wine-coloured dye-based stamp pads. Stamp images at random on brown wrapping paper and add a matching gift tag. Then top the present with fresh holly and a sugar candy cane, tied with red ribbon.

Emboss the message on the card with a black colour cube and clear embossing powder. Stamp the tree image in the same way, colour it in, cut it out and mount it on black card which you have cut with pinking scissors. Then highlight some areas with glitter glue for a bit of sparkle.

For the envelope, carry through the tree design and emboss it in gold. When you come to write on the envelope, use an embossing pen and gold powder.

Cleaning your stamps

You will need to do this every time you use a stamp to prevent colours from mixing and looking dirty, and to prolong the life of your stamp.

STAMP CLEANER

This comes in a small bottle with a felt top. Use it to scrub a stamp to remove ink and stains, then blot the stamp dry on a paper towel.

WINDOW CLEANER

Mix one part liquid window cleaner with one part water in a spray bottle. Spray this mixture on your stamp to clean it and blot on a paper towel. Be sure to label the spray bottle.

CLEAN-UP PAD

Add water to the pad, draw the stamp through it and blot dry on a paper towel. It is particularly good for cleaning off pigment inks. Place the pad in a deep tray (such as a seed tray or loaf tin) to stop it spraying your work.

How to clean stamps

Set up a cleaning area by using kitchen roll folded a couple of times – one sheet wet and one dry – and placing it in a seed or baking tray. (No, I didn't rubber-stamp the kitchen roll – it just happens to be the decorative sort!) Alternatively, use clean-up pads, which are available from stamp shops or do-it-yourself shops (called paint pads.)

To clean your stamps, just stamp first on to a wet towel and then on to the dry one. If there are stubborn stains you can use commercial stamp cleaner, or make your own by mixing liquid window cleaner with water.

If pigment ink gets stuck in the cracks, remove it with an old toothbrush.

 Watchpoint Always make sure that stamps are dry before stamping! Never soak stamps in water or the die may come off the wood.

Storing your stamps

Always store stamps away from heat or direct sunlight. Sunlight will harden the rubber and dissolve the glue.

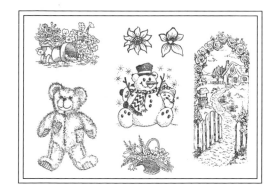

If you have lots of stamps, try storing them in seed trays that stack (by subject, *e.g.* animals, words, flowers, etc.). To make storage easy, stamp all your rubber stamps on a piece of paper that fits inside the seed tray. This enables you to see at a glance where the stamps belong.

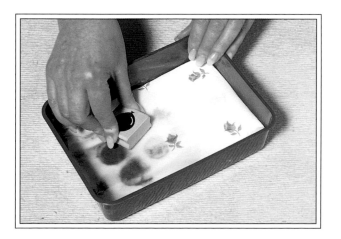

Index

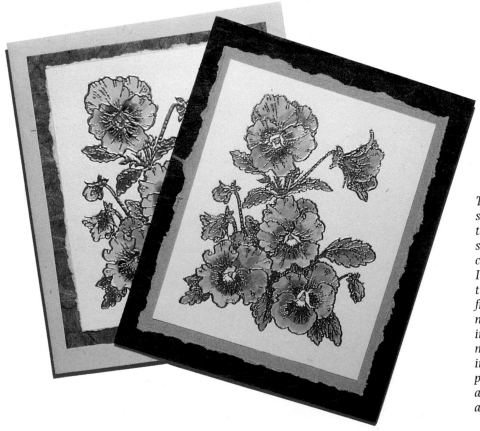

This pansy card, which is also shown on the cover, was simple to do, using a single large rubber stamp. Embossed in gold, it was coloured in using brush felt tips. I tried it two different ways for two completely different looks: first in pale lilac mounted on mauve mulberry paper, and then in yellow on dark-green mulberry paper. To get the irregular edges, do not cut the paper but tear it along the edge of a ruler – the fibres give an attractive effect.